COLOR BIRDZ

**#colorbirdz
began as an
Instagram challenge.**

*As Amarilys sought out to
explore her collection of
Dr. Ph. Martin's
Radiant Water Colors,
she painted a bird
to showcase each:
56 illustrations displaying
the colors of sets A, B, C and D.*

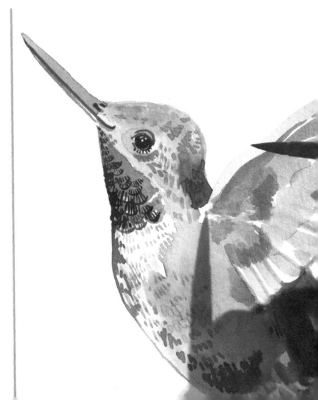

COLOR BIRDZ
CREATIVE INSPIRATION OF THE FEATHERY SORT
Art by AMARILYS HENDERSON
Showcasing Dr. Ph. Martin's Radiant Concentrated Water Colors

Visit watercolordevo.com for inquiries.
Cover design & artwork by Amarilys Henderson

Photograph of artist © Betsy Wall Photography
All other photos by artist.

Print Second Edition ISBN 9780578599519
Print First Edition ISBN 2370000587039
Ebook First Edition ISBN 9780692968130

Printed in the U.S.A.

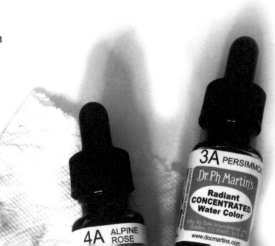

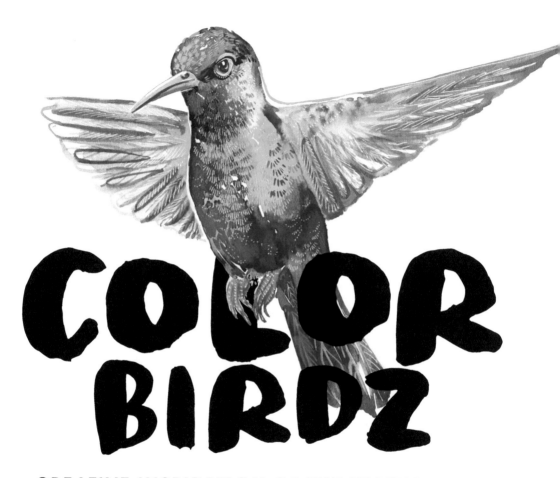

COLOR BIRDZ

CREATIVE INSPIRATION OF THE FEATHERY SORT

Art by AMARILYS HENDERSON

Showcasing Dr. Ph. Martin's Radiant Concentrated Water Colors

B 21
D 53
C 32

A 10
B 20
B 27

D 56
B 28
A 13

A 14

ICE PINK 37C *Pink Cockatoo*

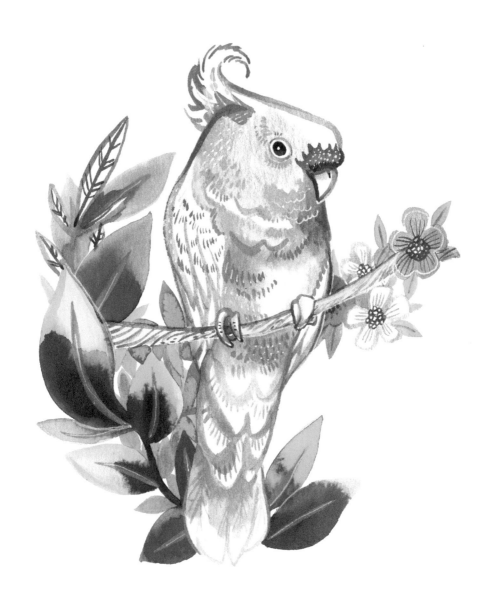

TROPIC PINK 39C *King Fisher*

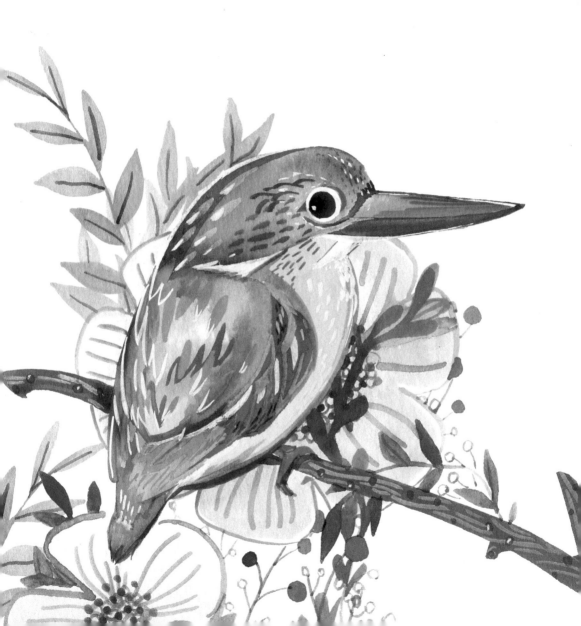

SUNRISE PINK 42D *Australian Galah*

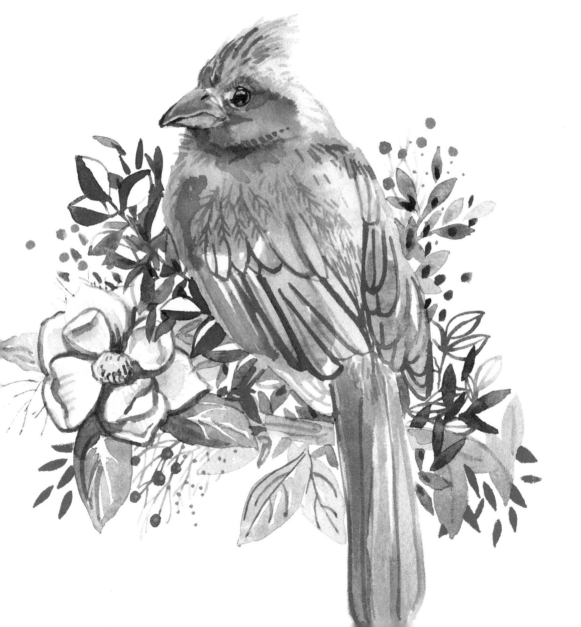

TAHITI RED 47D *Flamingo*

14

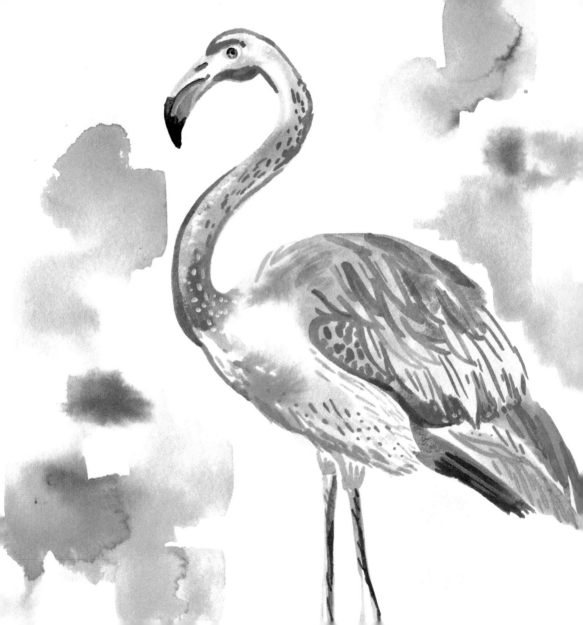

FUCHSIA 48D

Pink–Headed Warble

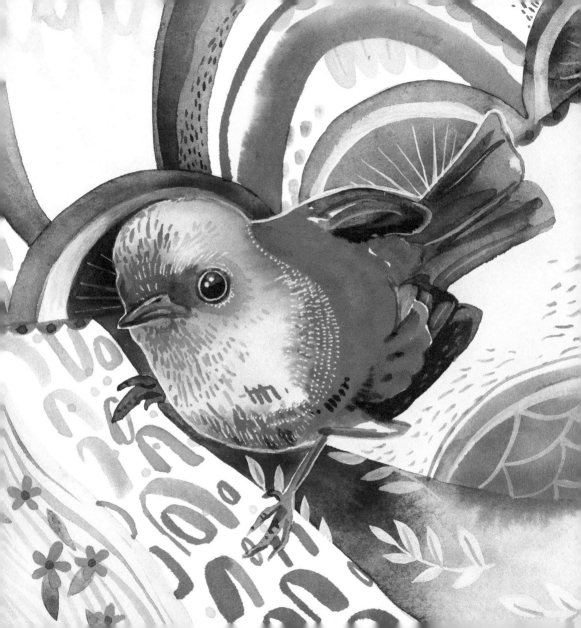

TANGERINE 17B

Flame Robin

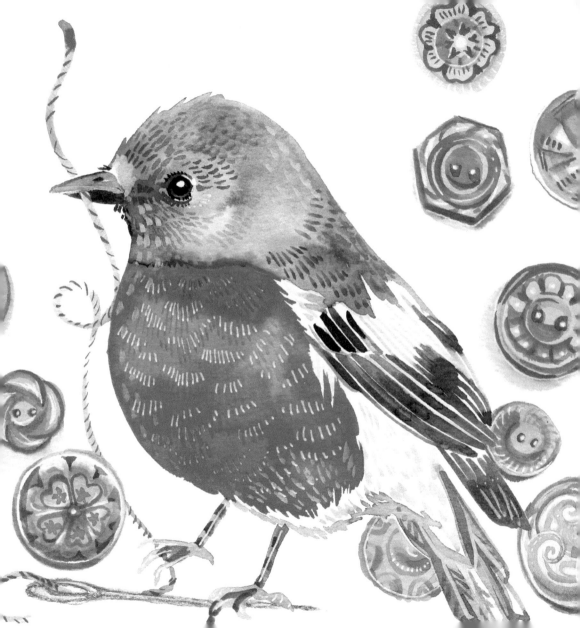

RASPBERRY 49D

Australian Galah

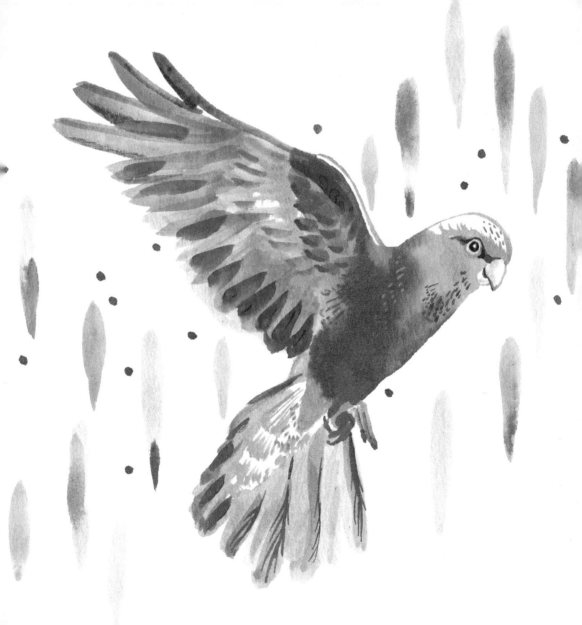

ALPINE ROSE 4A

Bourke's Parrot

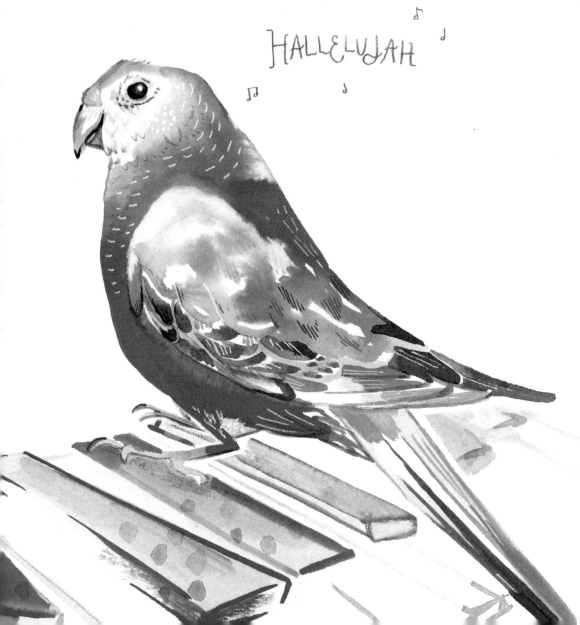

MOSS ROSE 7A *Sinai Rose Finch*

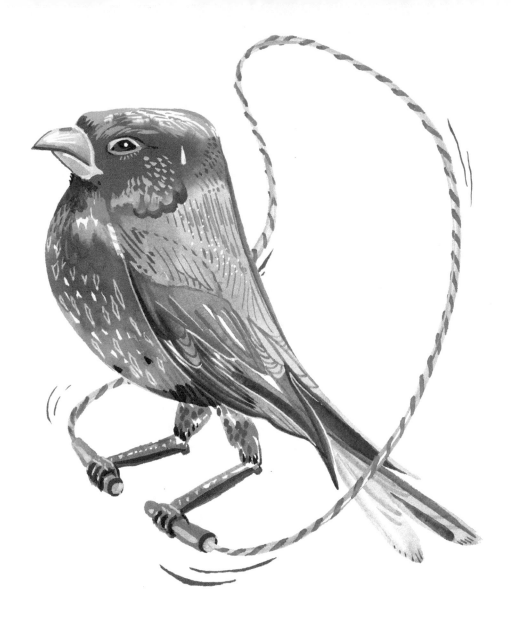

CHERRY RED 6A *Purple Finch*

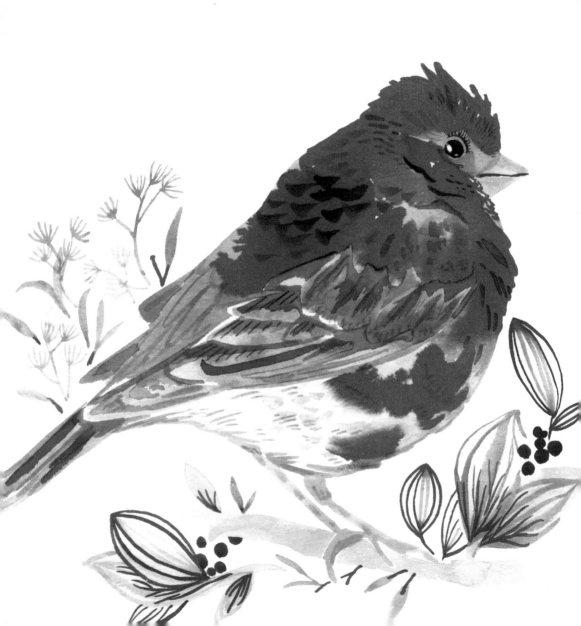

WILD ROSE 19B

Pink Finch

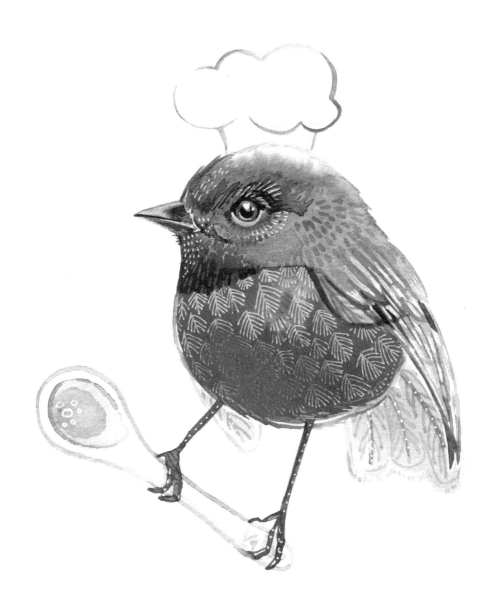

PERSIMMON 3A

Scarlet Ibis

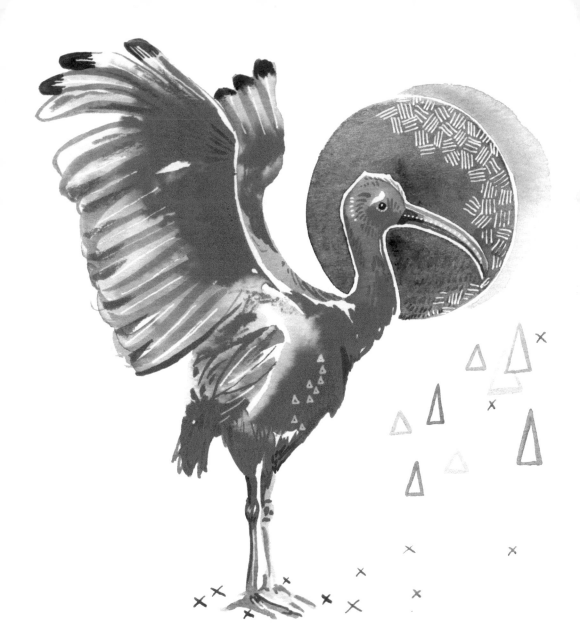

SCARLET 5A

Yellow–Billed Cardinal

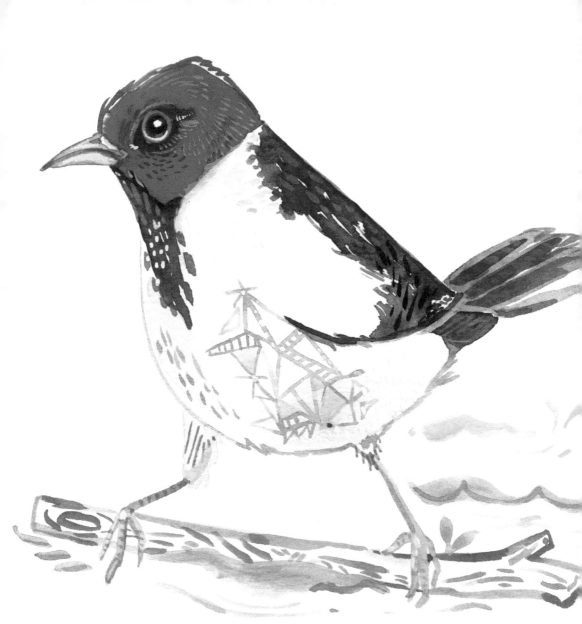

CRIMSON 18B *Red Cardinal*

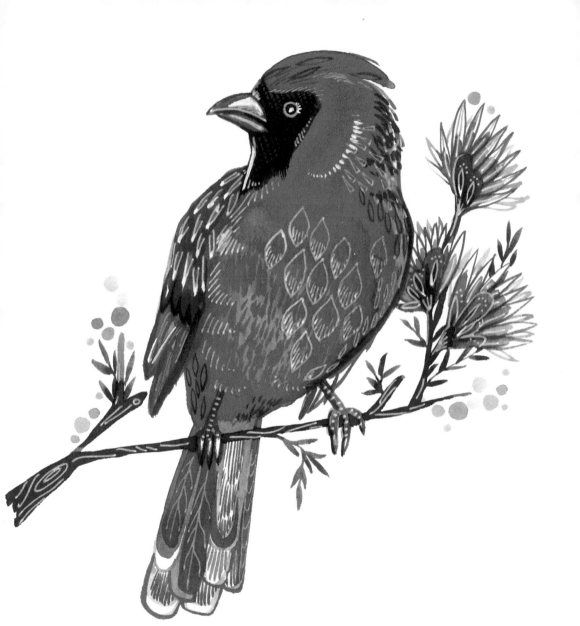

SUNSET RED 45D

English Robin

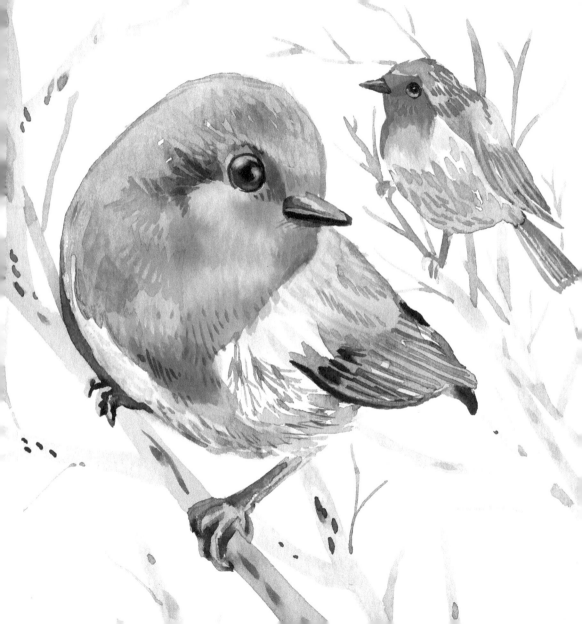

SUNSET ORANGE 44D *Chukar Partridge*

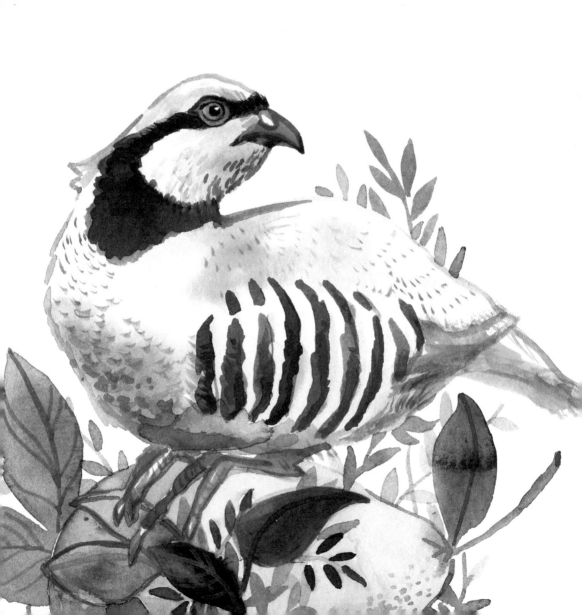

BURNT ORANGE 31C *American Robin*

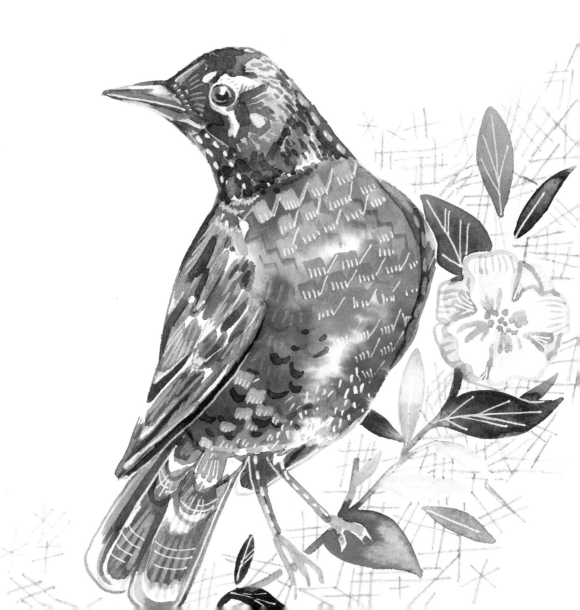

PUMPKIN 30C

Baltimore Oriole

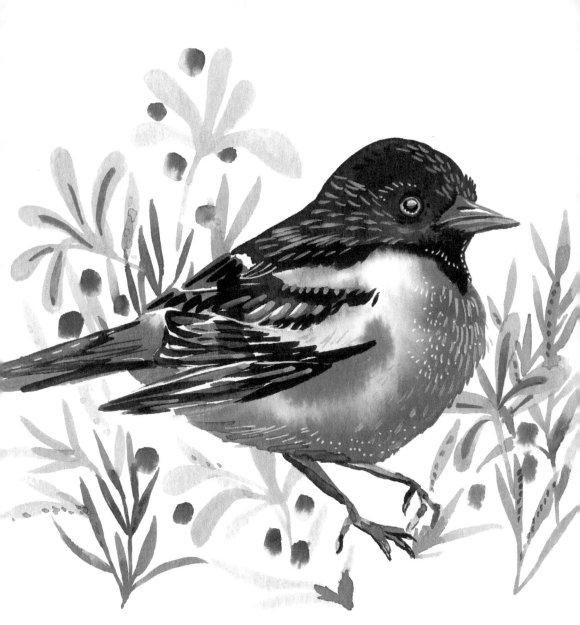

AMBER YELLOW 16B *Pheasant*

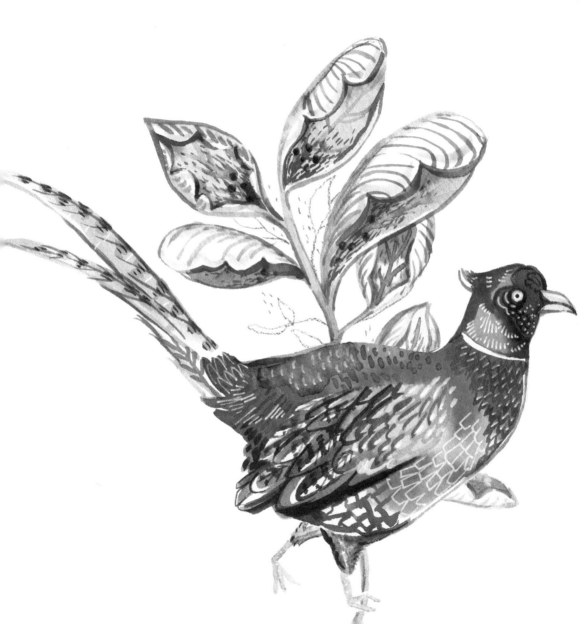

ORANGE 2A *Orange–Breasted Bunting*

46

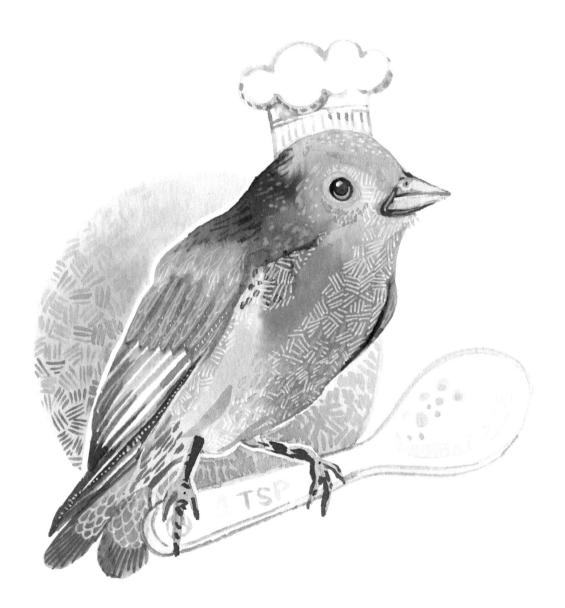

TIGER YELLOW 55D

Northern Flicker

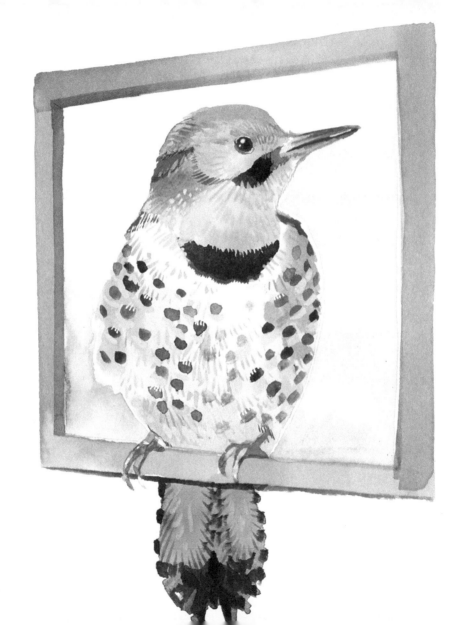

INDIAN YELLOW 54D *Diamond Firetail Finch*

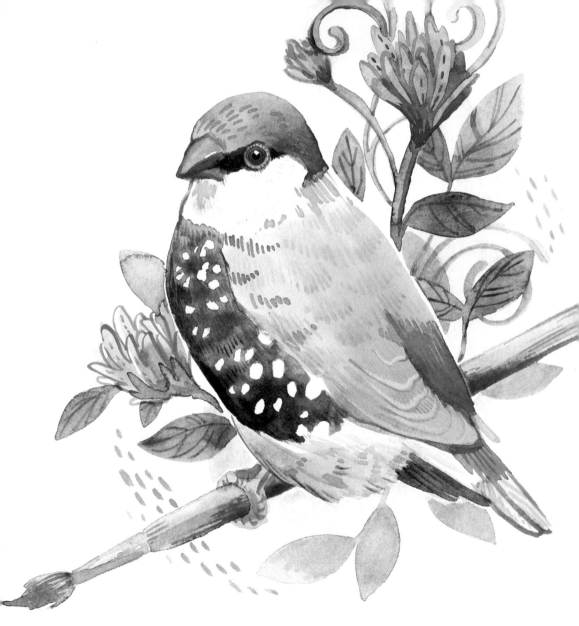

SUNSHINE YELLOW 43D *Goldfinch*

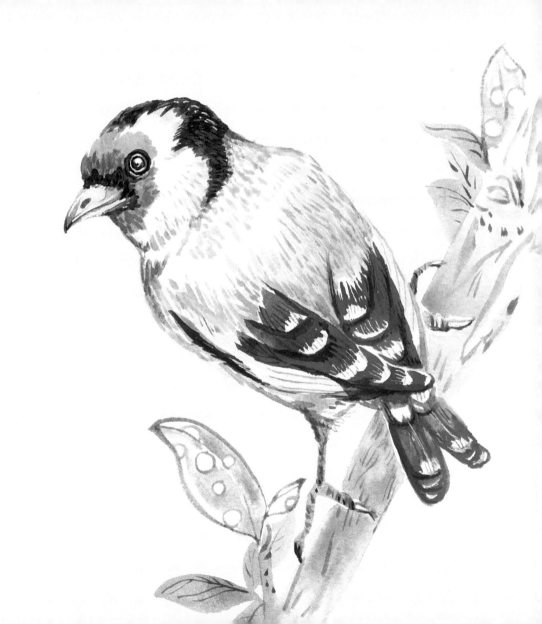

ICE YELLOW 40C

Cockatoo

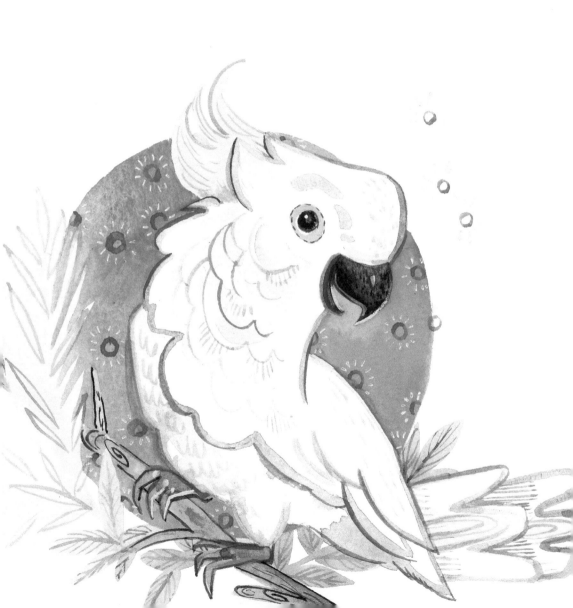

TROPIC GOLD 38C

Toucan

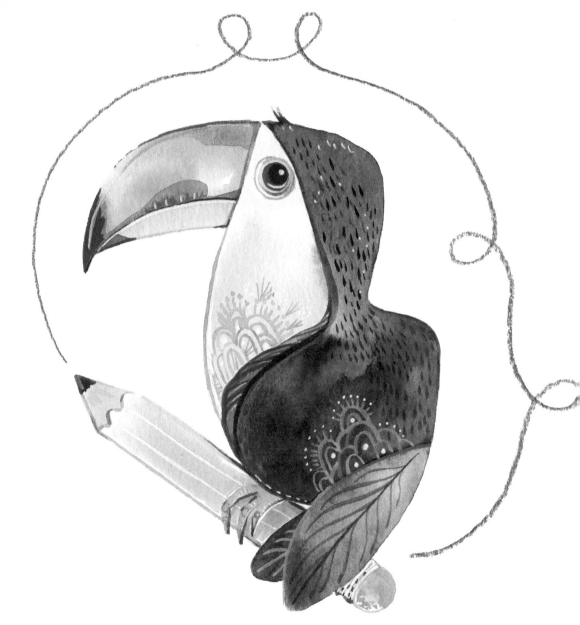

LEMON YELLOW 1A

Cockatiel

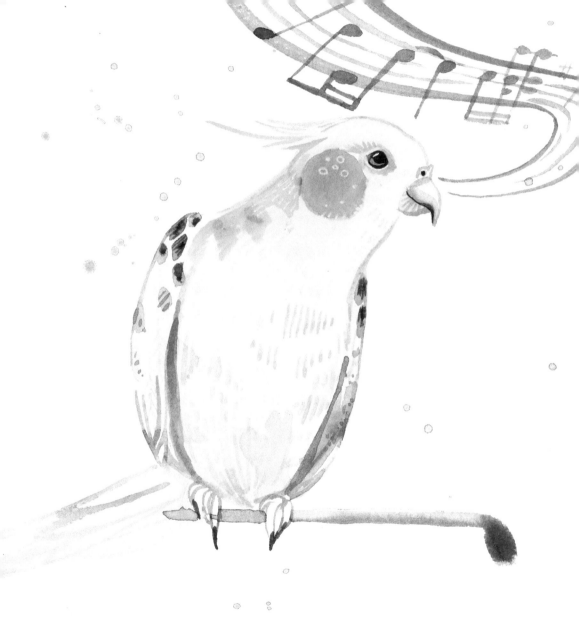

TAPESTRY 29C

Cardinal

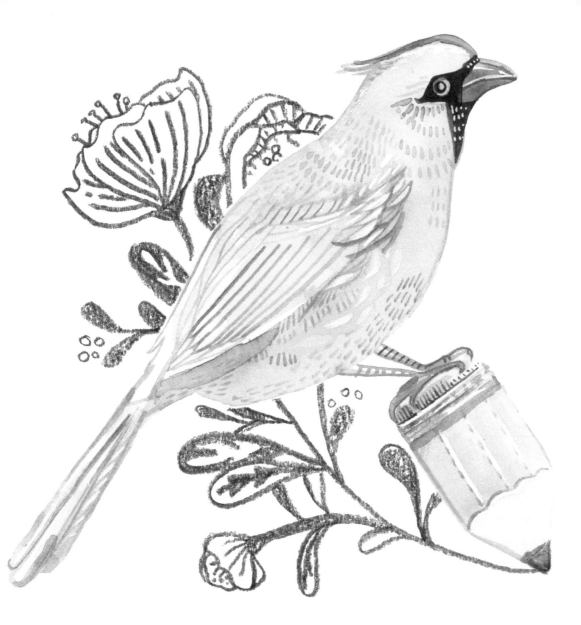

DAFFODIL YELLOW 15B *Parrot*

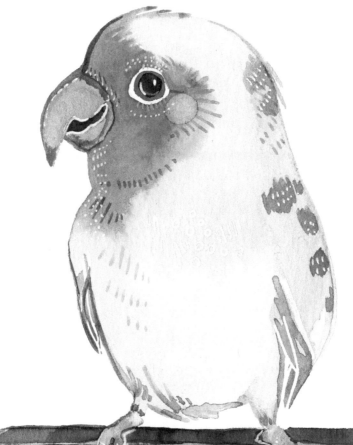

GOLDEN BROWN 26B

Screech Owl

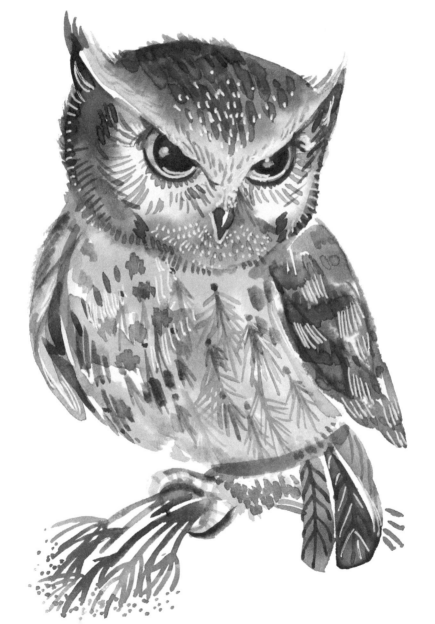

TOBACCO BROWN 36C

Wilson's Plover

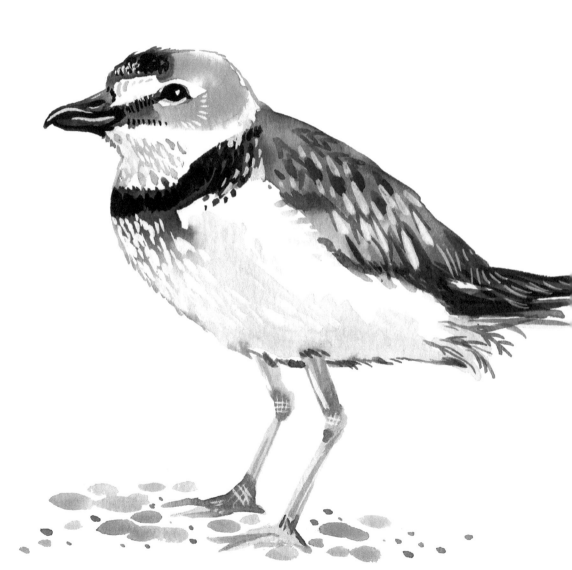

CHARTREUSE 34C

Magpie

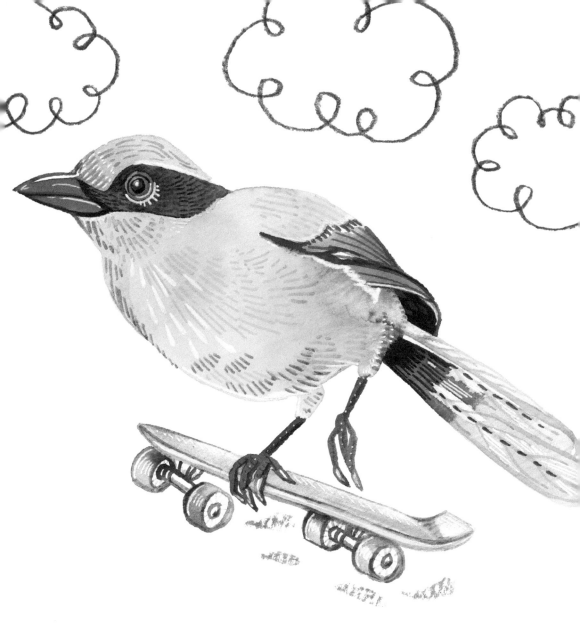

ICE GREEN 50D

Lovebirds

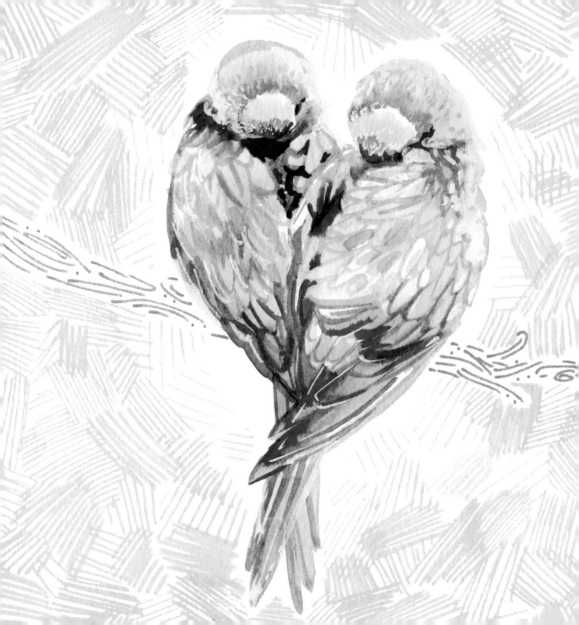

APRIL GREEN 23B

Parrot

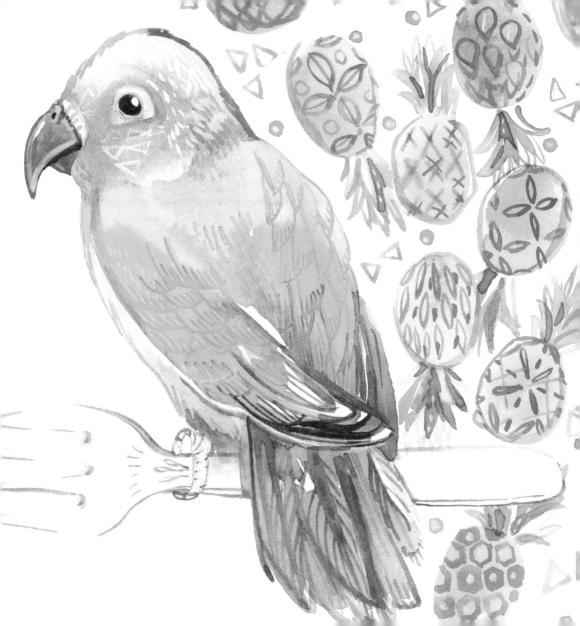

GRASS GREEN 11A *Parrot*

74

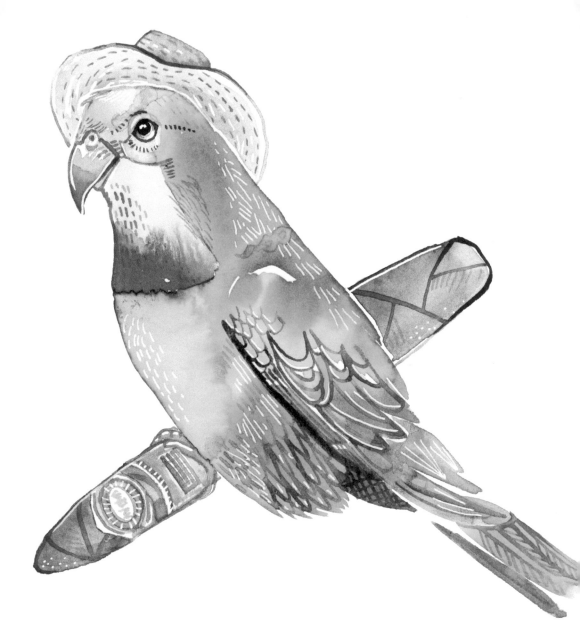

CALYPSO GREEN 41C *Green–Headed Tanager*

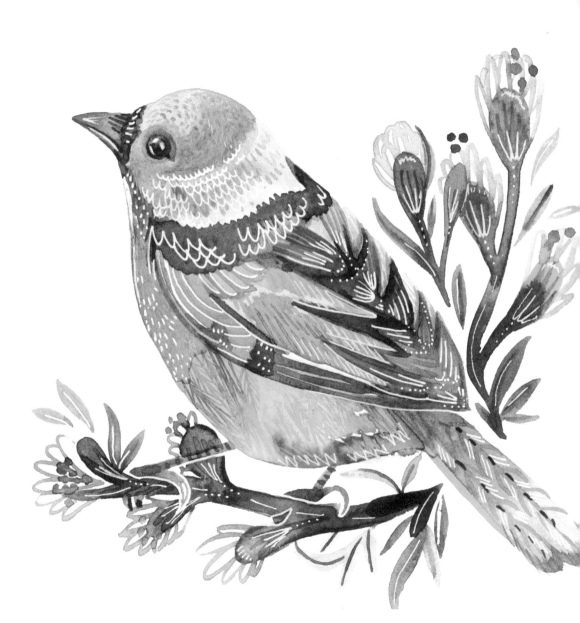

OLIVE GREEN 25B *Alder Flycatcher*

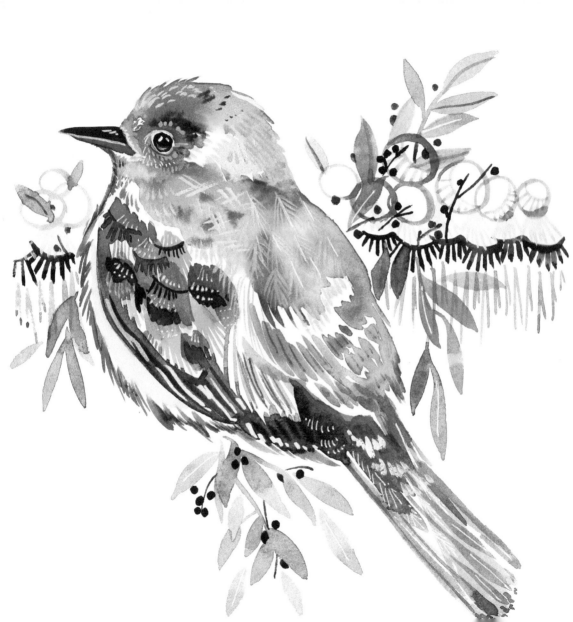

MOSS GREEN 24B *Hummingbird*

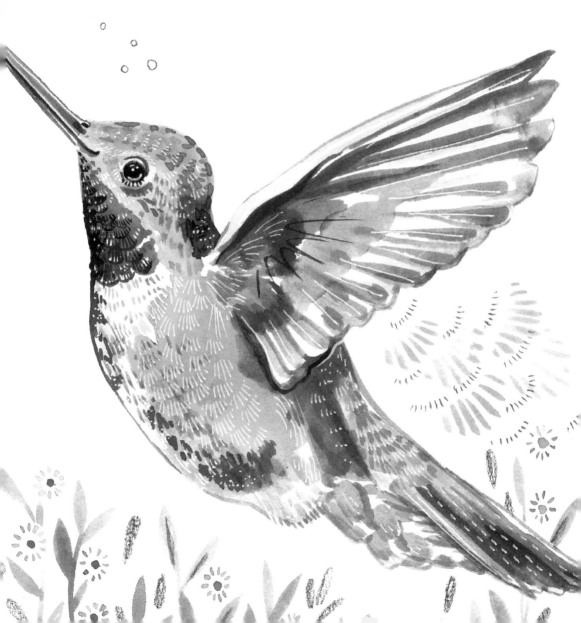

JUNGLE GREEN 35C *Taiwan Barbet*

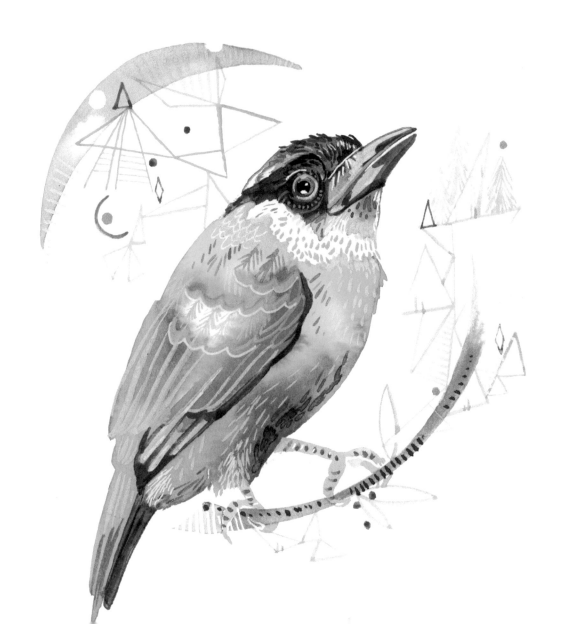

JUNIPER GREEN 12A *Hummingbird*

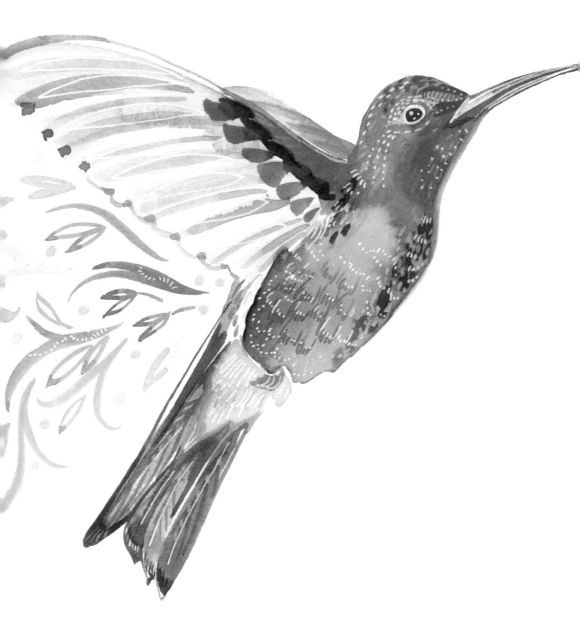

TURQUOISE BLUE 8A *Turquoise–Browed Motmot*

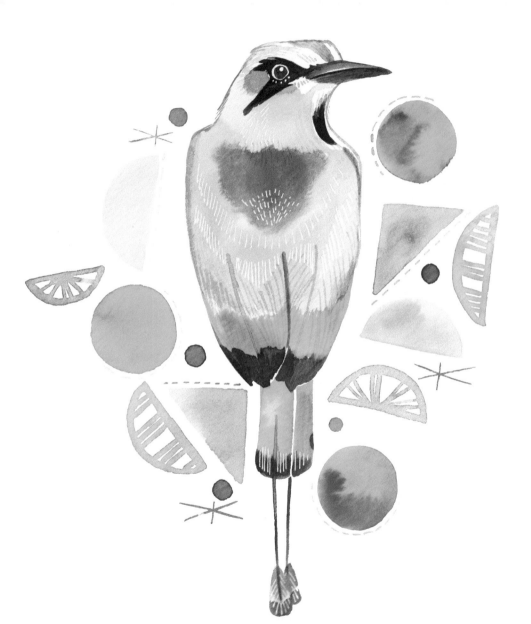

NORWAY BLUE 33C

Quail

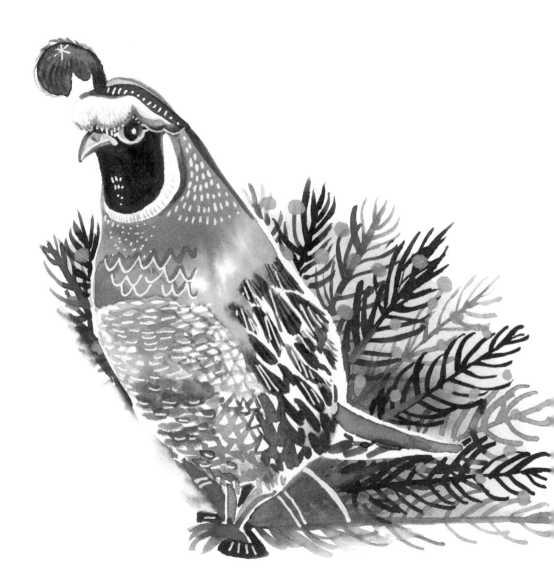

ICE BLUE 51D

Emerald Dove

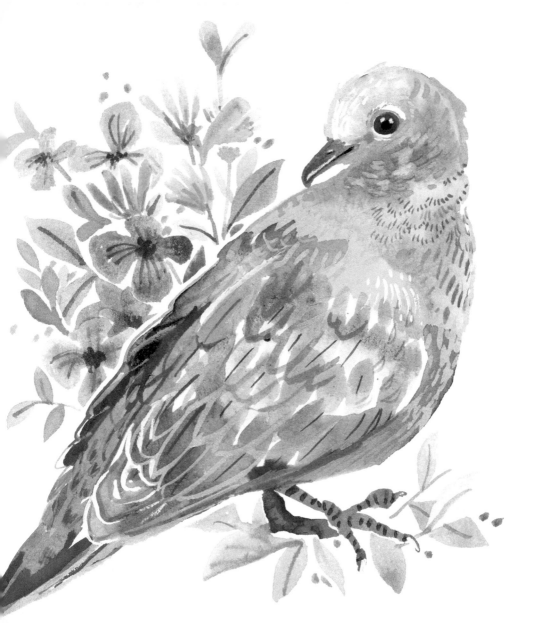

TRUE BLUE 9A

Silver–Breasted Broadbill

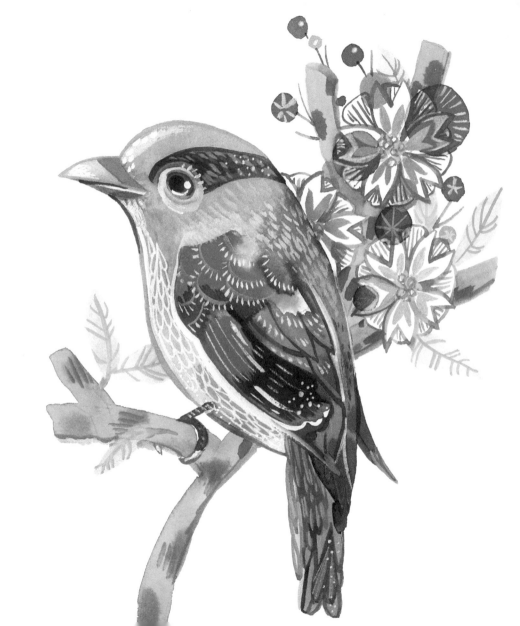

SLATE BLUE 22B

Blue Jay

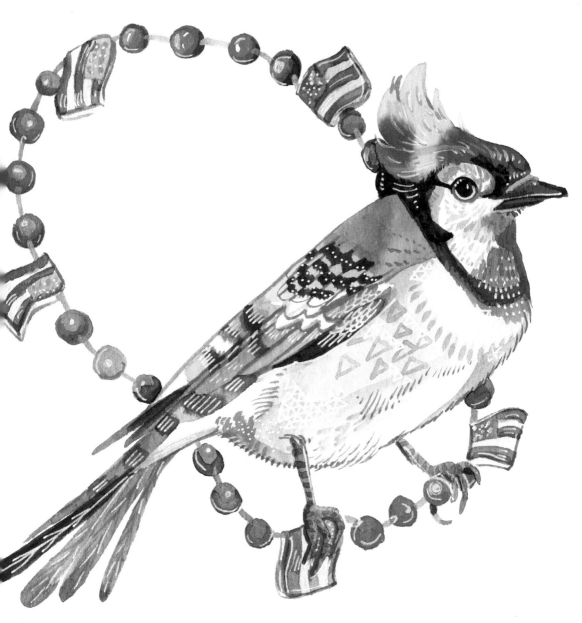

PEACOCK BLUE 52D

Peacock

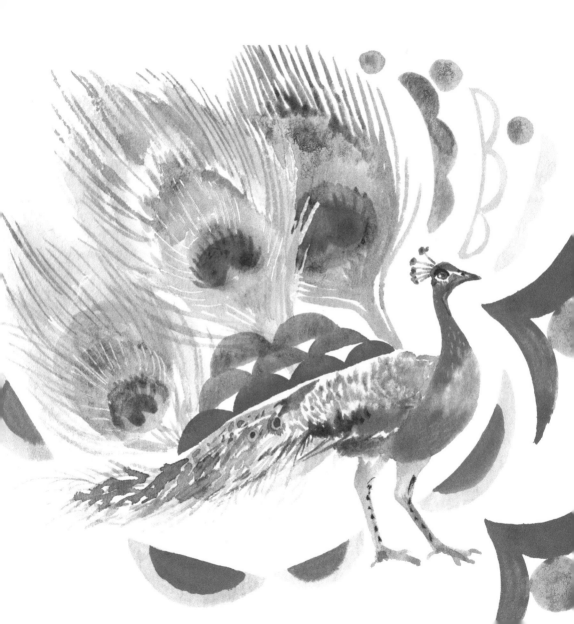

ULTRA BLUE 21B

Victoria Crowned Pigeon

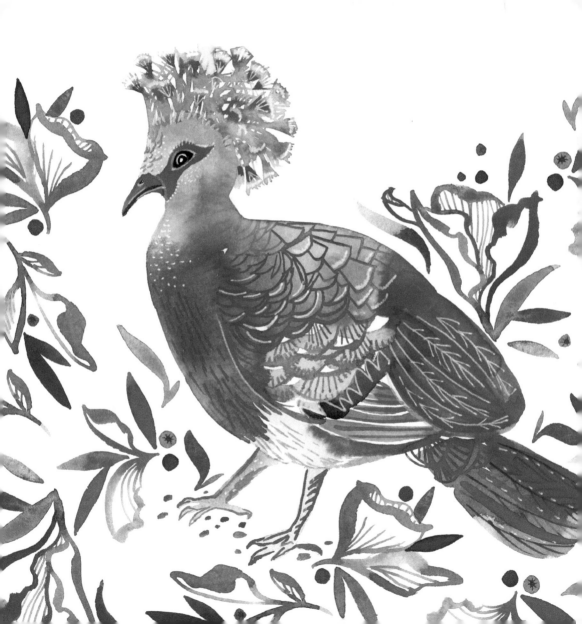

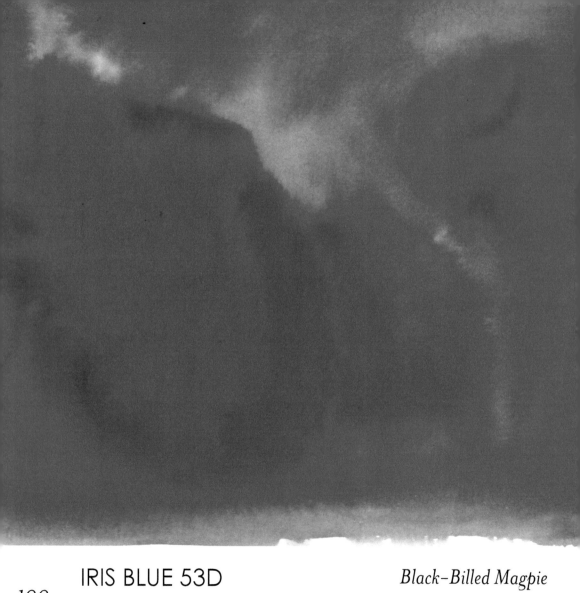

IRIS BLUE 53D

Black–Billed Magpie

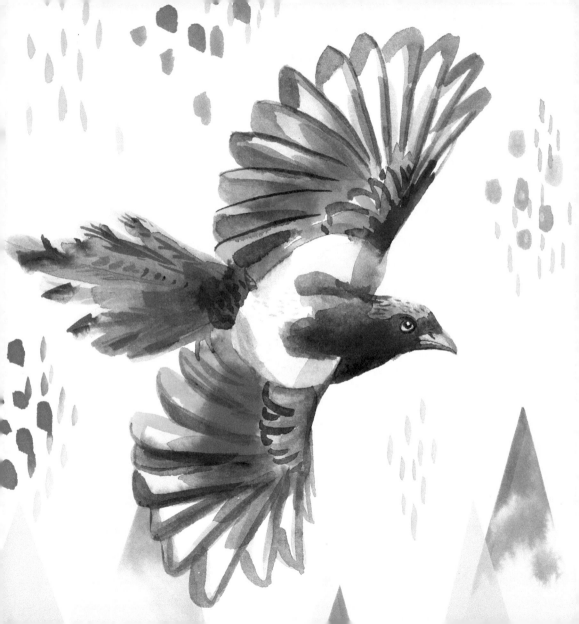

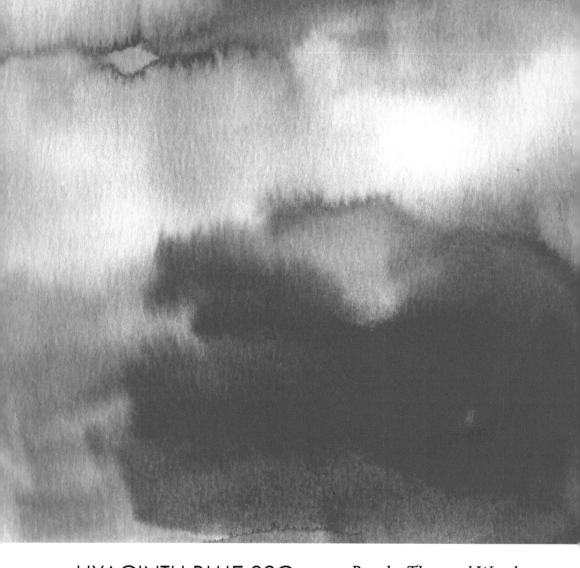

HYACINTH BLUE 32C *Purple-Throated Woodstar*

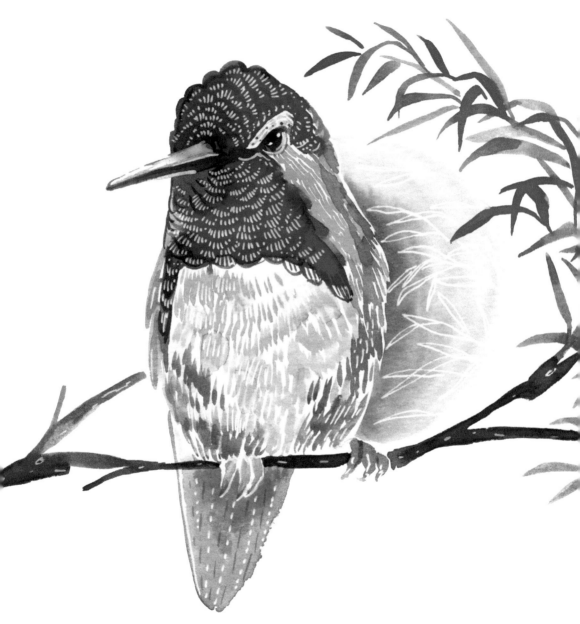

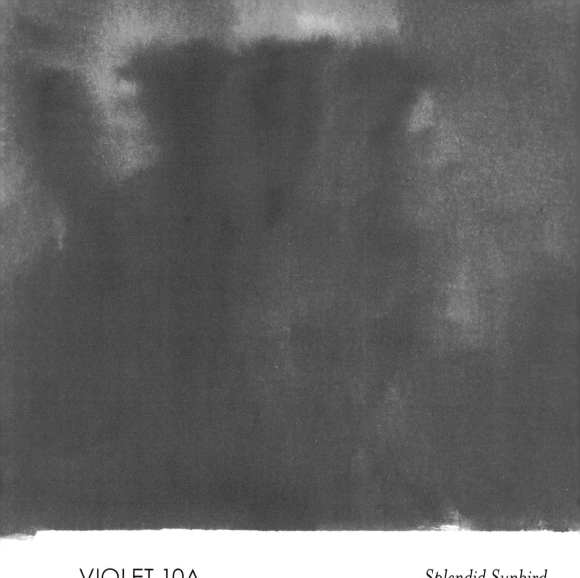

VIOLET 10A

Splendid Sunbird

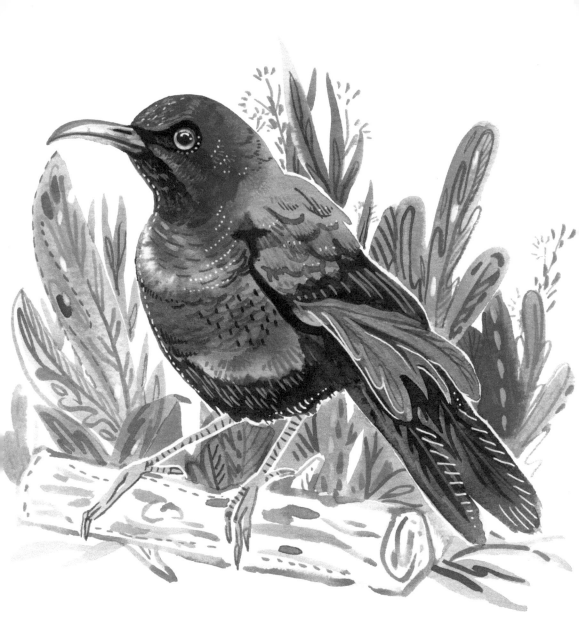

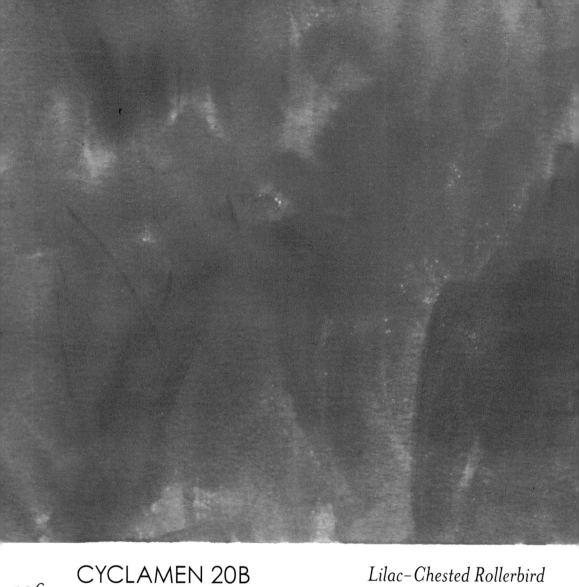

CYCLAMEN 20B *Lilac–Chested Rollerbird*

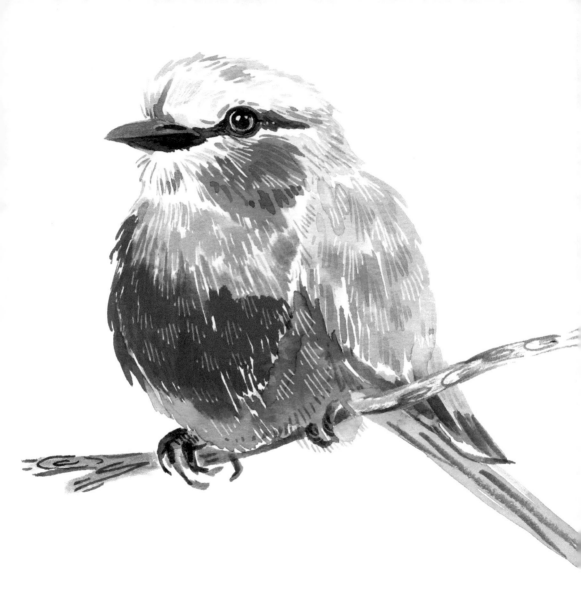

MAHOGANY 27B

Red Screech Owl

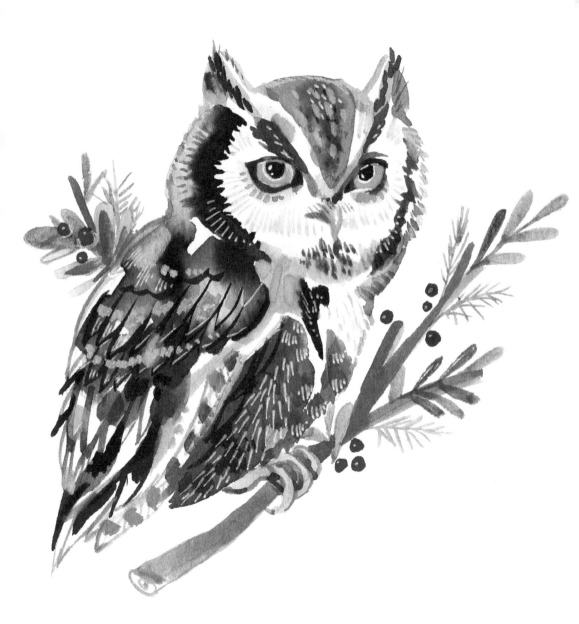

COFFEE BROWN 56D *Loon*

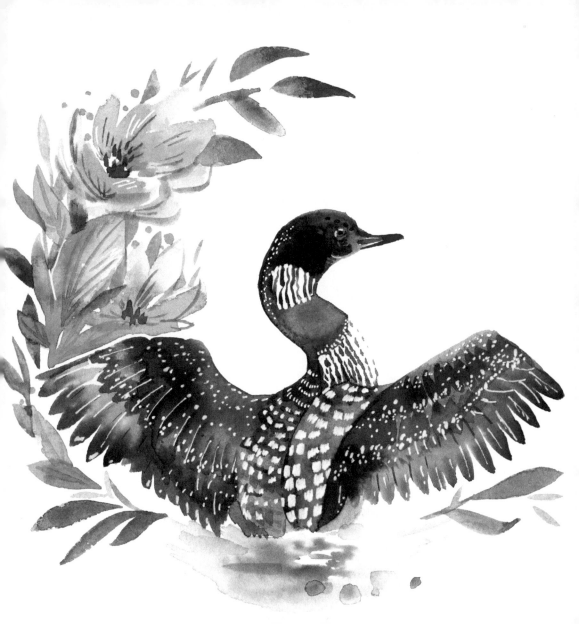

SEPIA 28B

Shore Bird

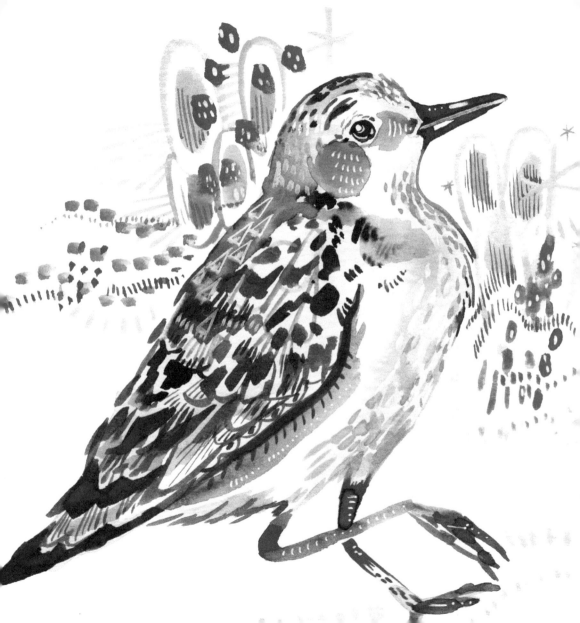

SADDLE BROWN 13A *Tufted Titmouse*

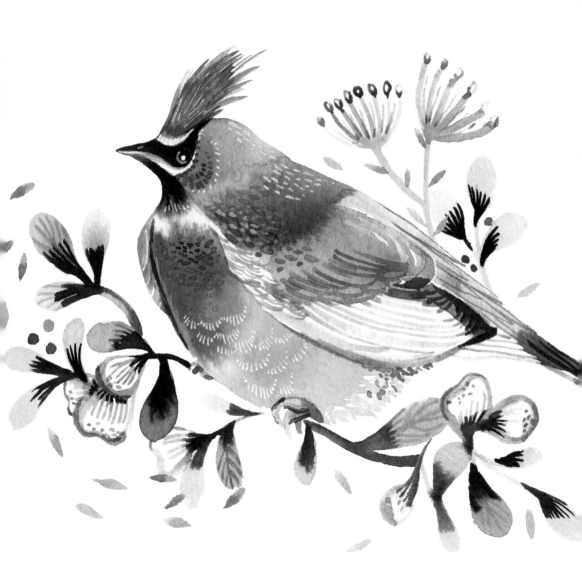

BLACK 14A

Tufted Titmouse

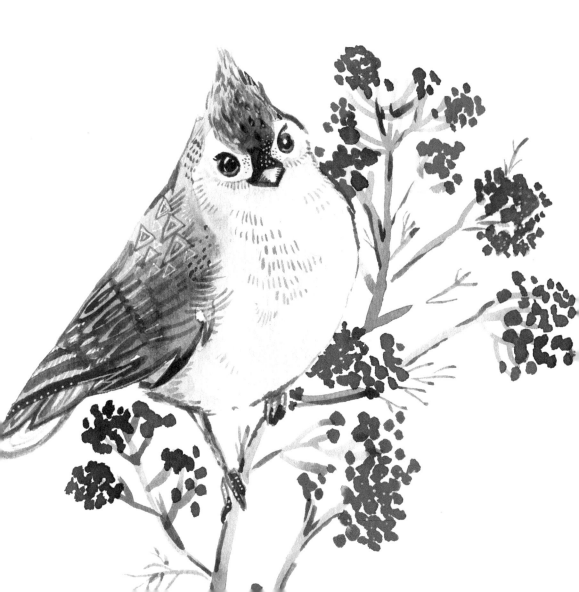

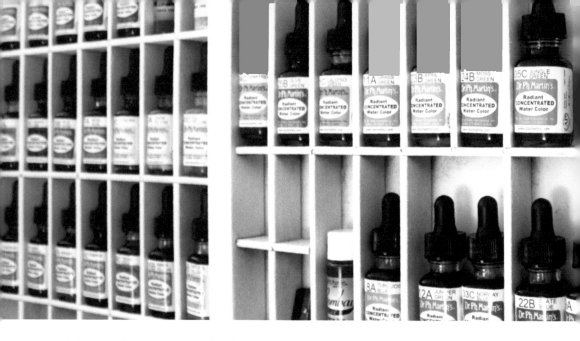

About the paints

For over 80 years chemists at Dr. Ph. Martin's have worked tirelessly on creating the best liquid watercolors, inks, and other color products.

Dr. Ph. Martin's Radiant Concentrated Water Color is produced in an extremely concentrated form to achieve the greatest possible brilliance. Each liquid color comes in an iconic 0.5 oz (15 ml) glass bottle package with its own eyedropper. Each set includes 14 different colors with a custom palette. Fifty-six colors in all are available.

Above: artist's collection placed in a re-purposed typesetter's drawer.

About the Artist

Amarilys Henderson works as an illustration artist, bringing the dynamic vibrancy of colorful watercolor strokes to everyday products—from paper to porcelain. A pursuit of vibrant truth, playful curiosity and design aesthetic influences much of her work, which found its renaissance in new motherhood and refreshed faith.

watercolor classes & more **amarilyshenderson.com**
instagram & twitter **@watercolordevo**

CPSIA information can be obtained
at www.ICGtesting.com
Printed in the USA
BVHW020243240920
589458BV00001B/15

* 9 7 8 0 5 7 8 5 9 9 5 1 9 *